CARTOONING

"Typography is the craft of endowing human language with a durable visual form, and thus with an independent existence. Its heartwood is calligraphy—the dance, on a tiny stage, of the living, speaking hand—and its roots reach into living soil, though its branches may be hung each year with new machines."

–Robert Bringhurst, *The Elements of Typographic Style*

"Cartooning is not really drawing at all, but a complicated pictographic language intended to be read, not really seen."

–Chris Ware, *The Whitney Prevaricator*

"[I am] a writer who draws."

–Saul Steinberg, quoted in Robert Long, *De Kooning's Bicycle: Artists and Writers in the Hamptons*

"The humble art of cartooning, at its essence, amounts to no less than a geometry of the human soul."

–Giambattista Vico, *The New Science*

CARTOONING

PHILOSOPHY and PRACTICE

IVAN BRUNETTI

YALE UNIVERSITY PRESS
NEW HAVEN & LONDON

PRINTED AND BOUND IN CHINA

The first version of this book was published in 2007 as a supplement graciously included with *Comic Art* Number 9, edited by M. Todd Hignite, designed by Jonathan Bennett (who has resumed his duties here), and published by Alvin Buenaventura (through his Buenaventura Press). A hearty thanks to Todd, Jonathan, and Alvin for their dedication to, and toil on, that project. For this revised and expanded edition, I thank my editor Michelle Komie and everyone at Yale University Press.

Thanks are due to Jonathan Wilcox for production assistance, Jonathan Bieniek for his eagle proofreading eye, Laura Mizicko for her tolerance (wholly undeserved on my part) and emotional support, and of course Chris Ware, without whose friendship, guidance, sympathetic ear, and aesthetic and moral perspicacity I would probably be (a) dead and (b) completely unable to articulate the thoughts contained in this booklet. For years our Saturday evenings were spent in a grim, gastro-intestinally challenging diner on Lincoln Avenue (where I had a crush on one of the waitresses), talking about anything and everything. Much of this book came from those conversations, and most of "my" best ideas were shamelessly stolen from him. Including the Deep Purple joke.

Other inspirations for me were Art Spiegelman's *Comix 101* lecture, Daniel Clowes's *Modern Cartoonist* pamphlet, and *The Imp* magazine by Daniel Raeburn. Richard Taylor's forthright *Introduction to Cartooning* was also a great influence, and I am probably unconsciously parroting his supercilious tone (if not his wonderful wit). Thanks to all the cartoonists I have quoted or paraphrased throughout the text. I hope I got everything right.

Candace Vogler (University of Chicago) and Paul Vaccarello (Columbia College Chicago) also deserve a special mention here, for hiring me to teach the courses that evolved into the book you are now holding. Finally, I would like to commend Charles "Chuck" Freilich, formerly of Columbia College Chicago, for talking me into teaching in the first place.

A note on the illustrations: I chose to use only my own drawings, mostly for practical reasons (copyrights, the cost of obtaining permissions, etc.). I have tried to make the drawings as simple, transparent, and unobtrusive as the typeface you are reading, and they should not be seen as any sort of "model" to emulate.

yalebooks.com

ISBN: 978-0-300-17099-3
Library of Congress Control Number: 2010940419
A catalogue record for this book is available from the British Library.
This paper meets the requirements of ANSI/NISO Z39.48-1992 (Permanence of Paper).

10 9 8 7 6 5 4

Dedicated to all my students, past and present.

Even the bad ones.

CONTENTS

ABOUT THIS BOOK

CARTOONING can be a lot more than just having fun drawing and creating jokes. This "classroom in a book" provides the aspiring cartoonist with a practical means for creative self-discovery and the exploration of complex ideas through the iconic visual language of comics.

You will get all the benefits of taking the cartooning course I teach, minus the distractions of the instructor's monotonous, droning voice, chronic absent-mindedness, soporific slideshows, and soul-crushing critiques. The seemingly endless tangential exegeses, however, have been retained.

You will keep a sketchbook that will function as a journal for notes, observations, experiences, memories, dreams, and anecdotes (and may even serve as an "art object" in and of itself). You will then develop and translate this material into various cartoon narratives, ranging from the simple construction of one-panel "gag" cartoons to a full-fledged multiple-page story. All the while, you will be encouraged to experiment with the wide variety of tools and media that can be used to create comics.

You will design characters, explore the various rhythms of storytelling inherent in the cartooning language, and compose panels, pages, and stories. The goal will be to move from rough ideas to initial sketches, and then to use this booklet as a sort of "process-oriented workshop" to refine those sketches into finished pieces.

This instructional guide will focus as much on "writing with pictures" as on developing ability in drawing.

INTRODUCTION

I t is likely the height of arrogance, not to mention utter foolishness, for me to attempt writing a book such as this. Considering that all human effort could perhaps be an Ozymandian folly, the search for meaning, catharsis, and dignity in the humble act of cartooning may seem an especially delusional quest. Perhaps this will end up as simply another "blip" in a long line of misguided, ineffectual primers written by mediocre cartoonists—a limp, halted spike in an already insipid graph of unworthiness. Who, after all, wants to take lessons from losers?

I would point out only that teaching is its own art, and one can be a good instructor despite not necessarily being a great talent in that field. A good teacher, essentially, brings out good work from the students, or rather points the students toward wringing good work from themselves. Sadly, comics (and art) are all too often taught with a tone-deaf, mechanistic approach that focuses unnecessarily on either superficialities or nonsensical theories (and sometimes both), which, in effect, teaches nothing of lasting value.

With the advent of the "graphic novel," cartooning has become (slightly) commercially and critically viable, compounding the problem. Undergraduate courses on comics could, I fear, spawn a wave of competent, but uninspired, work. Cartoonists of my generation and earlier at least had something to work against (disdain or outright indifference toward cartooning as a potential art form), which forced upon them a certain obsessive quality, as they pluckily created their own rules; this, in turn, made their work unique, visceral, and compelling. Comics are much less stigmatized today, and students want to dive right into their graphic novel, without any idea on how to structure a panel or page (much less a chapter or

book), or worse yet, without having anything other than vague themes to express, not understanding that themes emerge from stories, not the other way around.

I do not mean to sound presumptuous, as I am far from figuring it all out myself. I never intended to teach any courses on anything, and I did not so much stumble into teaching as get wheedled into doing it (but I figured I could use the extra money to pay off my dentist). I was terrified of taking this plunge into the unknown, as I had no idea that I could even fake doing an adequate job of it, much less enjoy it. To my surprise, I really liked teaching; maybe I am just a frustrated ham, and it was a way of performing. But it also helped me sort out and codify some of my thoughts on this creative endeavor upon which I had wasted most of the evenings and weekends of my adult life.

I should note that I have always held day jobs for sustenance, and I have yet, at age forty-three, to make a living as an artist. Thus, my course was not designed to churn out "professional" cartoonists, but really was about discovering one's creative process through this particular form (cartooning), simply because it was the one with which I was most familiar. I believe it is more important to teach students how to understand some basic aesthetic principles, through practice, than to dole out a few tips and tricks that encourage cleverness but not insight. The creative process of any art form, like a fractal, is a microcosm of the history, the evolution, of that art form. As in nature, evolution is a process of individuation: the undifferentiated tends to become individual, while the differentiated tends toward becoming a more indivisible whole. Well, this is all fine and good, but, again, who wants to take lessons from losers?

I am certainly no genius, but I have been fortunate enough to meet and become friends with quite a few of them, absorbing and synthesizing as much of their knowledge as I could. Therefore, they indirectly served as unwitting mentors to my students. Often I felt that I "lost" myself while teaching (a pleasant, self-annihilatory feeling of immersion) and was not articulating so much as merely channeling the storehouse of insights I gleaned from other, better artists—artists who did not necessarily enjoy clowning around

in front of a classroom of bored, angry, dismissive eyes. Teaching was an emotional rollercoaster, simultaneously exhausting and exhilarating, and I would drive home feeling spent, like after a long day of intense, non-stop sex with a new girlfriend.

I have taught essentially the same course to continuing education, undergraduate, and graduate students, both at an open-admissions art school and an exclusive liberal arts college. I have had a wide variety of students, ranging from the deeply perceptive and analytical (who taught me a few things) to one who took the class simply to "keep out of trouble on Wednesday nights." Sometimes the students were maddeningly lazy; other times they truly pushed themselves, and even kids I thought were hopeless rose to the task. It was so heartening, I could barely contain my tears. Teaching has reminded me that comics is still a relatively young, quite open art form, with a lot of unexplored territory. This is true in terms of both the language itself as well as the subject matter. Hopefully we will see a variety of different voices using the comics medium in the future, and this diversity should be a "shot in the arm" for readers and creators alike.

This book evolved from the classes I have taught, which in turn evolved from my own struggles with cartooning. Both the course and my own cartooning, I should add, remain continual works in progress. The cartooning classes I teach do not revolve around things like perspective, lettering, figure drawing, "shading," computer tricks, and the like, although I will gladly answer questions on these subjects (to the best of my ability) during the studio time. The diligent student can read entire books on these subjects if they wish (it never hurts), but the deepest realizations come to us from the daily practice of drawing. It is the pencil that teaches best, and anyway, the trees of theory can obscure the forest of practice. I would go so far as to say that practice is philosophy, for practice itself encompasses philosophy, and philosophy without practice is shallow indeed. A lengthy description of a glass of water is no substitute for the experience of drinking a glass of water; so it is with art.

Often I will illustrate certain unwritten laws or other principles of comics, but then I will show my students work by great cartoonists that violates that

same conventional wisdom. Rules are really just a safety net that allows us to get started; once the pencil hits the paper, everything changes, and one has to allow the ideas, characters, and stories to take on a life of their own. I am less concerned with "right and wrong" than with "good and bad." Often the best, most affecting work that students produce is surprising, unexpected, and not exactly the most polished.

Of course, there is a certain kind of student who will never "get" it, usually a narcissist blind to his shortcomings, not self-critical and often hostile to constructive appraisal. This type of student rarely if ever produces anything interesting to others (who could possibly stand someone so pleased with themselves?), instead concerning himself with facility over labor, style over substance, and showoffy technique over clarity. This type of student never sees form and content as inseparable expressions of the same truth, and usually slaps an inappropriate facade over a shaky foundation.

But structure cannot be imposed from without; it must develop, grow, evolve from within—only then can it come into proper focus. When form and content diverge, only a specter remains, and nothing solid can be built. It is like those ill-fated relationships where we convince ourselves that we are in love, when actually we are just consumed with lust, desperation, jealousy, and need. It is also the reason dictatorships and military occupations never last: anything that does not organically evolve from the needs of a society, but is instead imposed by an external force, eventually topples like the flimsy house of cards it essentially is.

For instance, I wrote an outline and countless notes for this Introduction, and no doubt this helped me organize my thoughts. But once I started typing, I had to abandon that outline and let each sentence dictate the next until a paragraph was formed; then, the process started again, and paragraphs flowed into other unexpected but inevitable paragraphs. Slowly, what I wanted to say began to cohere and crystallize. Actually, I am rather stuck at the moment, crippled once again by a horrible writer's block. And so I step back, opening the curtain for all to see my ineptitude, hoping this will shed light on the creative process.

It occurs to me that my struggles with writing prose are a weird inversion of my struggles with drawing comics. With comics, I know what I want to "say" but struggle with how to construct a language that says it. With writing, I do not give the form any thought at all, since writing comes more naturally than drawing for me (I am a windbag by nature) and I could not adopt a "style" even if I tried; however, with drawing, I still feel that I am confusedly building something by trial and error.

Drawing is like Italian for me: it is the language I first learned, and I still pronounce words in Italian first, in my head. It is almost like a geometric phonetics that happens in a split second (I see the words as shapes first). I occasionally still think in Italian (usually it is my father's reproaching voice, completely internalized by me), but it seems alien, clumsy, and embarrassing if I actually try to speak in it now. I feel like a child whose vocal cords have not developed as fast as his brain, or a cerebral palsy victim who is tortured by the content of fully developed thoughts that cannot be given vocal or physical form without several extra steps of mental "translation." Writing is more like English, my adopted tongue that feels more natural to me now. I do not give it a second thought; my writing style is like my breathing "style." It is just there. But the minute I think about it, focus on it, I freeze up, and it, too, seems strange and alien.

My brain is a tourist without a guidebook, lost in a maze of unfamiliar streets, overcome with mistrust and imagined dangers around every ill-lit corner. Ideally, comics would be the Berlitz book that translates my emotions to the "where is the nearest lavatory" of human communion. But writing this *Cartooning* book has underscored my inabilities and the folly of proclaiming anything. All I can say with certainty is that as a child I had to develop an "immigrant's ear," experiencing language not just as words and phonics but also as music, with all the nuance, subtlety, complexity, self-contradictions, and variation that implies.

And so, too, I have tried to develop a "cartoonist's eye." Because I suffer from severe myopia and thus a complete lack of depth perception (feel free to use these as mocking metaphors against me), with my right eye practically

blind, I have gone through life squinting at a very flat world. Everything I perceive has to be immediately translated and decoded through an elaborate mathematical system of shapes, ratios, and relative sizes before it turns into comprehensible visual information. This became apparent to me one day while driving on a desert highway, when a mosquito smashed into my windshield, directly into the self-constructed "anchor" point of my vision. My universe instantly exploded into disassembled shapes that had no connection or discernible relation to each other, like a paint-by-number of a Jackson Pollock canvas, and it took me a few panic-stricken moments to piece it all back together again into something that jelled as coherent scenery.

It is no surprise, then, that I see cartooning as primarily verbal, and through the prism of language, a translation of how we experience, structure, and remember the world. It would obviously be insane of me to saddle any student with these sorts of convolutions, so I tend to use a much simpler metaphor throughout the semester: food. Having grown up with Italian cooking, I feel that I am qualified to use this as a rubric for explaining the creative process.

Most Italian dishes are made up of a few simple but robust ingredients, the integrity of which should never be compromised. It is a straightforward, earthy, spontaneous, unpretentious, improvisatory, and adaptable cuisine, where flavor is paramount: not novelty, not fashion, not cleverness, and not prettiness. If it tastes good, it will perforce also look good (note that the inverse is not also true). It is a cuisine entirely based on a relative few, but solid and time-tested, principles. The techniques are not complicated, just hard; mastering them really takes only time, care, and practice. Originality, as Marcella Hazan instructs, is not something to strain for: "It ought never be a goal, but it can be a consequence of your intuitions." One plans a meal around what is available and what is most fresh, usually a vegetable, allowing this ingredient to suggest each course.

Perhaps all the lessons I am trying to teach in this book can be understood by making a quick, simple, unassuming dish, *spaghetti aglio e oglio* (i.e., spaghetti with garlic and oil), which will be either delicious or disappointing, depending on the quality of the ingredients and the

care taken to respectfully follow the cooking steps. The basic recipe calls for 1 pound of spaghetti (linguine is also OK), $1/2$ cup of extra virgin olive oil, a couple of garlic cloves (more if you love garlic), a little bit of hot dried chili pepper, and some chopped parsley. While the pasta cooks in 4 quarts of boiling water (to which is added a couple of tablespoons of salt, roughly the salinity of the sea), heat the olive oil with the chili in a pan on moderate heat. A few minutes before the pasta is ready, add the sliced or chopped garlic to the oil and let it turn golden—but not darker; otherwise, it will be acrid, tough, and indigestible. You will know it is ready not only by the color but when all of a sudden you really begin to smell the garlic. There is no substitute for intuition here and no room for error.

Once the pasta is ready (*al dente*, which usually means cooking it for a little less time than is suggested on the box), drain it, mix it with the garlic oil, and sprinkle with parsley. Make sure to use flat-leafed (i.e., Italian) parsley, garlic that is not too old (you can always remove the green "sprout" or core if need be), and the best-flavored extra virgin olive oil you can get. If prepared properly, the pasta will be lightly coated and slippery from the oil, the garlic and chili will release their aromas into the oil, and the parsley will act not as a decorative garnish (although the contrasting green undoubtedly adds visual beauty) but as an integral part of the dish's unity and balance of flavors. This will take you all of twenty minutes, even counting the time the pasta water needs to boil.

There are endless possible variations, modifications, and improvements on this versatile dish, which you will develop over time. You can use more or less garlic to your taste, add some parmesan cheese at the end, incorporate other ingredients (mushrooms, olives, what have you), or substitute cracked black pepper if you do not have chili. Once you know the basic principles, what you are "going for," you can add your own personal touch. The most important thing is the potential misstep at the beginning that can ruin the entire dish: don't burn the garlic. If you do, it will not matter what fancy or expensive ingredient you add to try to cover it up; it will still taste bad. Thus, what I hope, in essence, is that by the end of this book you will learn not to "burn the garlic" and to create art based on sound principles.

SYLLABUS

COURSE DESCRIPTION

This course provides students with a means for creative self-discovery and the exploration of complex ideas. Students will record their observations, experiences, and memories in a sketchbook and then translate this material into various pictographic narratives of varying lengths. We will explore the rhythms of storytelling, discuss the formal elements of comics, and compose comics pages using this iconic visual language, all the while experimenting with a variety of tools, media, and approaches.

LESSON PLAN

Week 1: Spontaneous Drawing
Week 2: Single-Panel Cartoons
Week 3: Four-Panel Strips
Week 4: A Simple Page
Week 5: The Democratic Grid
Week 6: The Hierarchical Grid
Week 7: Tools
Week 8: Style
Week 9: A Full-Color "Sunday" Page
Weeks 10–14: A Four-Page Story
Week 15: Conclusion

REQUIRED TEXTS

No additional texts are required for this course; however, there is a list of recommended readings at the very end of this book.

TERMINOLOGY

This bears some clarification. Throughout this course, I will use the terms "cartooning," "cartoons," "comics," "strips," "comic book," and "graphic novel," among others, almost interchangeably, depending on the syntax necessary for any given sentence. Cartooning is the process itself, as well as a language and an art form. Cartoons are the things a cartoonist creates. "Comics" is also a term I will use for this same language/art form, as well as the actual finished object ("Joey drew a comic" or "Joey drew some comics"). I may use the term "strip" for a short sequence of panels or even an entire comics page. Although "graphic novel" is a fancy, disingenuous, logically inconsistent term for a comic book, we seem to be stuck with it. A graphic novel is a physical object (a book containing comics), to be sure, but also an art form, or even an aesthetic movement (which we can alternatively call "art comics" to differentiate it from commercially driven "product"). The terms "alternative" and "independent" comics seem a little murky and too relative, so I will avoid them altogether. A few pretentious cartoonists, embarrassed by their chosen profession, still tend to favor the moniker "comics artist" because it (supposedly) sounds more respectable than "cartoonist." Fortunately, its usage tends to be on the wane, and I will avoid this term as well. I see the term "graphic novelist" being bandied about more and more often these days, but I find it kind of clunky and, to put it kindly, unmellifluous. When we are creating comics, we are not "graphic noveling," we are cartooning.

COURSE STRUCTURE AND RATIONALE

If you want to get the most benefit from this terse little tome, you must follow the weekly lessons in the exact order presented here. You must do all the exercises and assignments. The exercises are meant to be done in a quicker and more relaxed fashion. Let yourself experiment, and do not worry about doing something "wrong." They are exactly that: exercises. On the other hand, the assignments are much more involved, and you are expected to spend more time on them.

Do not skip any of the assignments, jump ahead, or fudge on the instructions. The assignments increase in difficulty, scope, and complexity each week; moreover, each assignment builds upon and incorporates everything that was learned in all the preceding ones.

The first two-thirds of this course can be likened to a cartooning boot camp, because you will be expected to follow what seems like a strict and inflexible set of parameters or constraints. The reward, however, is that you will have much more freedom, control, and (hopefully) skill for the final project.

THE SKETCHBOOK

The sketchbook is, in many ways, the backbone of this course. Now, you do not have to purchase an expensive sketchbook if you find that too paralyzing (I know I do); even a cheap notebook (or set of notebooks) will do. Ruled or unruled paper, large or small, it really does not matter as long as you feel comfortable. You will use it to work on the exercises, make thumbnails (and in some cases the final art) for the assignments, and for any other writing and drawing you wish. The importance of drawing in your sketchbook, even if it is simply some crude scribbles and scrawls, for a little bit every day cannot be underestimated. Just as a professional athlete has to perform some sort of physical exercise each day, so, too, does the cartoonist constantly have to draw, whether it be absent-minded doodling or detailed drawings from life.

So, then, you are no doubt wondering if this is primarily a drawing class or a writing class. Well, it is both and neither. The goal of this course is to fuse elements of both writing and drawing into another form altogether: cartooning. We will use pictures as words, and words as pictures. If you follow the advice presented herein, you will begin to see the world through the eyes of a cartoonist.

Although technical expertise in drawing is by no means a prerequisite, if you practice drawing from observation (from life, photos, other art, or whatever is at hand), you will necessarily learn to construct pictures. Even

the most simplified and "cartoony" drawings will have a compelling presence and solidity. The ultimate goal is to make your drawings "readable," to communicate what you are trying to express.

RULES AND REGULATIONS

Laziness is not tolerated here. Please do not use this course to make "conceptual statements" as an excuse for not drawing. For instance, the old "handing in a blank sheet of paper as a minimalist comic" trick is not going to pass muster here.

Collaborations also go against the spirit of this course. Now, there is nothing wrong with collaborations per se, and you will still find this course useful even if you eventually end up working with a collaborator or on a "team." But since I want each student to see cartooning as an indivisible, organic whole, and for students to find their own individual "voice," it would be best to work alone on the projects.

Occasionally, I have annoying students who insist on writing a "script" for someone else (often another unsuspecting student in the class!) to illustrate. My advice in these cases is simply to drop the course. Imagine taking a creative writing course with the intention of "coming up with ideas" for plotlines that another student would actually compose into sentences, paragraphs, and stories! Or taking a literature course and complaining that you're not allowed to play basketball in class. This is not a course based on free-form, random pedagogy.

While we are on the subject, let me stress that typing out scripts is discouraged in this course. Rather, you will be thinking of comics in more visual terms, moving narratives forward visually, and considering panel, page, and story layouts as a whole. This method will still be beneficial for anyone who plans on working in a part of the assembly-line comics industry that requires scripts, because you will be more sensitive to how and what the hired artist actually has to draw.

Another no-no is the willy-nilly bending of the course requirements and instructions to suit one's own pre-existing project. This, too, contradicts the

spirit of the course. Please see the note above regarding the course structure and rationale.

A WORD ON GENRE

Sometimes I hear about comics being referred to as a genre. While I can understand the basis of this—since the term "genre" can be defined very broadly and comics are generally misunderstood by most people—it still makes me cringe.

What I mean by "genre" here is a type of hackneyed story with predetermined elements in predictable combinations. While it is perfectly all right to use genre as a way to "enter" a story if there is no other way to approach a particularly painful or confusing topic or emotion, you should refrain from relying too much on this overly trodden soil.

Another reason I tend to discourage using certain genres such as fantasy or science fiction is that, on a purely practical level, it is sometimes difficult to judge these works. It may be impossible to discern what is actually being drawn in any given panel, but the student can easily retort, "That's what plants look like on the planet Zoltron X-9" or "That's a gnome from the Kingdom of Wort; their hands are supposed to look like that." Sometimes a student can actually pull this sort of thing off, because their work may have something weirdly compelling about it. Generally, though, it is easier when the external referents are somewhat connected to the consensus reality most of us share. At the same time, this course can help the student give life to a more internal world, since what is cartooning, ultimately, but a consistent and identifiable system of communicative marks expressing our unique experience of life?

Another problematic genre is the political or editorial cartoon, with its facile and smug symbology, which often seems manipulative and insulting to the reader's intelligence. The political value of comics (or art in general) is dubious at best, in my opinion. I have always said, "Political cartoons are the ass-end of the art form" (which is admittedly cruel of me). Political cartoons are often too reductive and lacking in nuance or subtlety. Occasionally,

some heavy-handed or ham-fisted cartoon causes a great uproar. Well, if one sets out to offend a group of people with an image or cartoon, and one has a large forum, such as a newspaper, the cartoon will probably get a reaction. But I question the value of that. It seems like a predictable little dance: someone draws something purposely to offend another, and then that person gets offended. Yeah, great.

Life and people, I believe, are a lot more complicated than that. It seems that (strictly) political cartoons can prompt one of two reactions: if you agree, you nod approvingly (but not really laugh), and if you disagree, you mutter something about the cartoonist being "an asshole" (and also not laugh). At best, the aim is to polarize people by relying on extreme viewpoints, and at worst, to pussyfoot around the issues for fear of actually offending somebody.

Either way, everything is strictly in black-and-white terms, with no in-betweens, and I would much rather read a story about full, complex characters going about their lives. I think stories about human beings are still going to address political issues, if they deal with reality at all, but in an implicit rather than explicit (or worse, didactic) manner, thus generously and sympathetically allowing the reader to decide what to think. I guess one can argue that everything is political on some level, but then there really is no need to sledgehammer the reader's head.

USEFUL TOOLS
The only tools absolutely required for this course are:

 Paper
 Pencil
 Life

All else is vanity; however, most students invariably ask for additional guidance regarding specific tools. Here is a list of products that are pretty common among professional cartoonists. You certainly do not need to pur-

chase these exact tools or brands, as you may use whatever you ultimately feel most comfortable with; moreover, you will likely go through a long period of trial and error before you find the tools most suitable to your temperament. Do not be discouraged; this is actually quite normal and, in fact, healthy.

I often think that, were my arms to be cut off in some tragic accident, I would still feel compelled to scrape my gums against the sidewalk in order to create a comic strip with my own blood. What is most crucial is the desire, the need, to express oneself. The tools, or means, can be improvised from whatever is at one's disposal.

Consider the following a very rough, informal guide, and please excuse my extemporaneous and probably ill-informed commentary.

Brushes
Windsor & Newton Series 7 watercolor brushes are expensive but of the highest quality. Number 2 is the most commonly used. The Number 3 is a bit larger and thus has a heavier line and is harder to control. You could, of course, decide to go smaller and use a Number 1. Purchase a variety of sizes and determine which suits you best.

If you do not wish to spend too much money, cheap vinyl brushes actually work fine. They may wear out faster, but, as there is no need to be precious with them, you will feel less bad about throwing them away. Cartoonists such as Chris Ware and Seth use Loew-Cornell brushes.

If a brush is too intimidating and you prefer the familiarity of a pen, there is always the compromise of a "brush pen." Pentel makes a nice Pocket Brush Pen, and I am sure there are quite a few other high-quality Japanese brands available as well.

Crowquill or "dip" pens
Hunt 102 is probably the most commonly used. Hunt 108 and 99 are nice points as well, but harder to master, as they are more flexible. I am told Hunt 22 is also a viable option. Gillotte makes good nibs, but I am not as familiar with these. Try a variety of nibs and see which you prefer. A

general rule of thumb: the more flexible and versatile the tool, the more difficult it is to master (but the rewards are perhaps greater).

Technical pens
The most common brands are Koh-I-Noor and Rotring. These are good for making straight lines, or when using circle and ellipse templates or other drafting tools (such as the so-called French curves). They are called technical pens because, traditionally, they were used by draftsmen. They give you an even line width and can be moved in both directions, unlike a crowquill pen, which has to move in one direction only, lest it snap and break.

(To this day, we cartoonists are dependent on the quaint, old-fashioned tools and media of draftsmen and architects of the previous few centuries; let us pray that these items do not become obsolete or prohibitively expensive!)

Also popular are Micron pens, which come in a variety of sizes. These do not need to be refilled and are more like markers than technical pens. My theory is that they are not as archival as India ink, but my students inform me that I am completely wrong. Some of my favorite artists, in fact, use this type of pen, and their work reproduces quite nicely, so it is likely that I am "off my rocker."

Some cartoonists eschew all of the above and instead prefer to use good-quality fountain pens, filling them with India ink.

India ink
I tend to buy a big bottle of whichever brand is on sale. Some recommended brands are Pelikan, FW, and Dr. Marten's Tech Ink. I usually end up with Koh-I-Noor or Higgins brands. These are a little on the thin, watery side, but I find that leaving the bottle of ink open helps the water evaporate, thus giving the ink a thicker consistency. They are not as jet-black as the others but still work fine. You can dilute the ink with water for washes (or even use black watercolor in combination with the ink).

Bristol board
Strathmore is the undisputed classic here. The 500 and 400 series are the

best for cartooning. If you ink with a dip pen, you might want to use the smooth (or plate) surface. If you ink with a brush, the vellum surface might be better for you. If you really get deeply into this whole comics racket, you might also invest in the 3-ply or even 4-ply Bristol boards, which are much stiffer than 2-ply. They look and feel weightier (because they actually are). When you are just starting out, 2-ply is fine (and in fact many cartoonists never use anything heavier than that). In any case, Strathmore is the best brand, I have found.

Illustration board (if you don't want to use Bristol board)
Get the "hot press" kind, which is smoother and works best with India ink. Again, vellum is best for brush, and smooth or plate surface is best for dip pens. I have not used illustration board in many years, so I cannot recommend a specific brand. Note that illustration board is not translucent enough if you are inking over a light table or light box.

Ames lettering guide
These are available at most art supply stores, although you may have to search hard or ask for it. Not essential, really, but many cartoonists rely on this small contraption to line up and control their lettering.

Pencils
You can use any variety you like. Softer leads are easier to erase if you press lightly, but they can be a problem if you press hard on the paper. Harder leads are nice because they are light enough that you can go over your lines and rework or refine them as necessary, plus you can remove them easily at the scanning stage if your eraser does not catch them all. Non-photo (a.k.a. "non-repro") blue pencils are great because you do not have to erase them at all (they can be removed at the scanning stage). This keeps the black ink nice and dark on the page and often makes for a better-looking original. Experiment until you find something that "clicks" for you.

* * *

Corrections

Unless you are planning on making your comics in editions of one, you will be reproducing your work via some printing process. Ultimately, you should feel free to use any means available to you to have the printed piece appear exactly as you would like it. This means you will probably need to make corrections on your originals. Do not be embarrassed by this: the end result is the only thing that counts. While a pristine, error-free original is a beautiful thing to behold, cartooning should not be treated as a superhuman feat or some sort of parlor trick.

Sometimes a mistake can be interesting in its own right, and some cartoonists even go so far as to embrace the smudges and cross-outs as part of their aesthetic. In fact, this can give the artwork a visceral, expressive power or even a tentative, searching quality that might not otherwise be possible. As you continue drawing, you will have more control of your craft, and you will be able to discern if this approach "works" for a particular strip.

In the beginning of our journey, though, we will likely opt to correct our spelling mistakes and inadvertent smears. In these cases, the eraser tool in Photoshop can be a great help. You can also use an X-acto blade to scrape off excess ink from your board (this may actually give the work a pleasing, rough-hewn character). Failing that, you will need some sort of corrective fluid. At this beginning stage, Liquid Paper, Wite-Out, or another brand may be your best option. Pentel correction pens are very good quality and allow you to draw over the dried correction fluid. Be forewarned, however, that these products are likely not archival. If you do not need to draw over the correction medium, you can use white acrylic paint (Pro-White is one well-known brand; don't be put off by its inadvertently menacing-sounding name). The proliferation of manga and anime in our culture has also led to the import of some Japanese brands of correction inks. I cannot vouch for these, but I hear they are actually pretty good. Good ol' white ink can also work. Dip your crowquill or "ruling pen" (a drafting instrument) directly into it and draw or letter. This technique is useful not only for mistakes, but for drawing over a field of black ink. For large errors, you might want to use Avery mailing labels. Place them over the offending section and draw right on top of the label.

Like many things in life, the key here is trial and error. You will find your preference depending on your temperament and needs.

Other
There are many other, less traditional, possible techniques, each with its own set of specialized tools: scratchboard, colored pencil, watercolor, gouache, marker, paper cut-out, collage, etc. Feel free to experiment and incorporate these tools and techniques into your work, but avoid doing so arbitrarily or thoughtlessly, or to disguise the lack of content or structure in your work. This would be akin to spraying a sickly sweet perfume over a pungent, unbathed body.

PHOTOGRAPHY

I suppose I should say something about photography; namely, please do not use it in the assignments. If, in your free time, you want to take photographs as a way to strengthen your compositional rigor, that is of course a wonderful idea. Snap away!

Unfortunately, in a comics class, the use of photography tends to be born of laziness. It opens up a quagmire of theoretical questions about "what is comics" and turns attention away from the actual content of the story or from someone's inability or unwillingness to "push the pencil" (which is probably wholly intentional on the student's part).

We need not concern ourselves with these theoretical conundrums at these early stages of developing our cartooning ability, and photography just confuses matters. Besides, in the context of comics, photographs usually have a lurid, oily (one might say pornographic) verisimilitude that feels incongruous and wrong, like when you see an eleven-year-old girl walking down the street wearing leather pants.

I am perfectly willing to admit that someday a cartoonist may come along and prove me entirely wrong, and I would invite—welcome, in fact —him or her to do so.

* * *

A FEW WORDS ON COMPUTERS

This is actually quite a complex subject that could fill up another book. Suffice it to say that this course is not dependent on the use of a computer. Some basic tips are included, but since the world of computers changes so fast, I am sure anything I write will probably be outdated by press time. At this juncture in history, pencil and paper are still much cheaper, more portable, more practical, and more accessible than computers.

It is partly for this reason that I would encourage you to teach yourself the art of cartooning via these low-tech, traditional media. Another reason is that the very word "cartoon" is etymologically tied to paper: "cartoon" originally meant not only the preliminary sketch for a painting but also the paper upon which the sketch was drawn (from the Italian term *cartone*, pasteboard). Cartooning primarily involves composition, and it is best to learn this art on a humble sheet of paper, where we can easily consider the edges and try to create a sense of motion (life, even) within a static space.

It is so easy to incorporate temporal elements, such as sound and movement, into comics presented via the computer screen that we are instead veering into the art of animation, and thus film; furthermore, features such as "interactivity" lead us even further from the cartoon into the realm of video games. Undoubtedly, some entirely new art form will arise from these crosscurrents, but, again, that will have to be the subject of another book.

I know a couple of great cartoonists who draw directly with the computer, but they use it well precisely because they first learned how to draw and design (really another word for compose) on paper. Alas, students tend to use the computer merely as a shortcut, and often an ill-considered one at that.

There is nothing sadder than watching students furiously erase line after line after line on their Wacom tablets, until they create a "perfect" one, unaware that they may be merely illustrating something preconceived and unquestioned. There are two fundamental flaws here. One, the students are erasing the invaluable evidence of their process, their thinking, their struggle, their search. Two, the students never risk losing control, and thus never

learn to regain control of the tool, or even allow the tool itself to suggest an unforeseen mark. There is no discovery, only micro-managing.

Most often, students insist on typing their lettering with the computer, oblivious to the overall aesthetic effects of mixing machine typography and hand calligraphy on the composition as a whole. Thus, I am going to have to forbid the use of computer lettering (yes, even a font of your creation) for the first ten weeks of this course. I would first like students to become sensitive to the page and all the marks upon it as a holistic entity, the appreciation of which will be immensely helpful, even for those who later end up using computer lettering. After the first ten weeks of doing it the "hard way," students are free to make their own decisions on the final assignment.

Even if a student decides to pursue "webcomics," that student will benefit by learning to respect and compose within the parameters of the sheet of paper, bringing out its full potential, as this will help him or her do likewise with the computer screen.

I suppose I could have added the computer to the list of useful tools above. In fact, I use the computer quite a bit, especially for scanning, archiving, and coloring my work (via Adobe Photoshop), not to mention pre-press production (via Quark and, soon, InDesign). Today, Photoshop has turned into a necessity—if not for the cartoonist, then for the person(s) doing the actual production work in preparation for the printing process. The intent of this course is not to describe the functions of these programs, although they will be discussed briefly, but rather to focus on developing our creativity first and foremost.

If you are reading this in the future on a virtual screen projected from a nano-optic device, or from the supercomputer embedded in your anal microchip, please ignore everything I have just said (about paper, anyway).

SPONTANEOUS DRAWING

Cartooning is built upon the Five Cs: calligraphy, composition, clarity, consistency, and communication, each reinforcing the other. We will consider the doodle as the fundament of cartooning. Accordingly, the following exercises should stress minimalism, dynamic drawing, and clear, simple lines.

Exercise 1.1
Using your sketchbook and a pencil or pen of your choice, spend 3–4 minutes drawing a car. Then, start over and draw it in 2 minutes. Then 1 minute. Then 30 seconds. Then 15 seconds. And then 5 seconds. Draw faster at each step—that is, draw the entire car within the time limit. Repeat this same process for four other subjects: a cat, a castle, a telephone, and a self-portrait.

Compare the spectrum of your drawings, the qualities of the more detailed drawings versus the quick doodles, and note that because of the time constraint, they probably became more simplified and linear at each step. The challenge of cartooning is finding a good midpoint, where the finished drawing is solid and unmistakable but still retains some of the "oomph" of the doodle.

Note also that as the simplest doodle emerges, when we really have too little time to think about the drawing, we get closer to the "idea" or essence of the thing being drawn. Here we begin to see the universal, latent, symbolic, visual, mnemonic language that is comics. You will probably surprise yourself as you spontaneously create these simple icons (pictograms, really) that can still convey all the essential information about something.

* * *

Exercise 1.2
Draw quick doodles (5–10 seconds each) of famous cartoon characters, from memory. Try to do at least 25 characters, more if possible.

Note that often these drawings are, technically speaking, "wrong"— but also kind of right at the same time. One can tell who the character is supposed to be, even though it need not be strictly "accurate." (Is there a Platonic ideal of these characters, anyway?) There seems to be some autonomous core to these characters that can be represented with just a few lines, or key elements. The thing that allows us to recognize the letter "A" whether it is typeset or handwritten in a cursive scrawl, despite all the possible variations, is the very same orthography that makes cartoons work.

Note also that one would need a reference to draw these characters "on model," and in that case, any little mistake or deviation would stand out. This is instructive, as it shows that even having a reference to make sure everything is drawn "correctly" does not always help one's cartooning. In fact, if one begins to draw a comics page with a great amount of detail, one has to keep that level of detail generally consistent. Any imperfections pop out a lot more and can distract from the reading process. An interesting thing to consider is: at what point would a doodle of a character not be recognizable as that character anymore?

When drawing characters quickly from memory, one can be quite inaccurate, almost as if one is inventing new characters, and these "mistakes" can serve as the basis for new character designs. This allows students to see their own styles more clearly. A page full of these doodles can help a student discern certain qualities that are consistent within his or her set of drawings. These qualities are a clue as to what makes one's particular visual handwriting different or unique, and these should be embraced by the student.

Art Spiegelman once told me of a quote by Picasso: "Style is the difference between a circle and the way you draw it."

Exercise 1.3
Here is a little "Zen" exercise. Pencil out a grid (or grids) in your sketchbook,

Figure 1. A smorgasbord of doodles.

enough to contain 100 small drawings. Now, spending no more than 5 seconds per drawing, let your stream of consciousness guide you, drawing whatever word comes to mind (do not stop to think about it). Examples: persons, places, objects, occupations, concepts, emotions, etc. You should, at the end, have a little system of pictograms.

HOMEWORK ASSIGNMENT 1.1
Create an 8½ x 11 inch "doodle" page, in black and white. Strive for spontaneity in your drawings. The page can be in either horizontal or vertical format. Make sure to have a dense variety of drawings, arranged into a harmonious composition. You may cut and paste from many separate sheets of paper or draw on only one sheet, using some sort of a grid system or a more free-form arrangement, but combine all the drawings into one overall image that has some sort of organizing principle. Hint: you can draw at a larger size, and reduce the image via a photocopier.

HOMEWORK ASSIGNMENT 1.2
Collect 12 small objects that have some element or quality in common, and bring them along to next week's lesson.

SINGLE-PANEL CARTOONS

This week we will focus on composing a single image that tells a story, and we will also begin to incorporate words as an integral part of the whole. Because we will not always be able to stand over the shoulders of our readers, explaining to them what they are seeing and what it all means, we must develop the ability not only to draw clearly, but also to compose the image so that it makes visual and narrative sense.

It is at this early stage that I begin to ask tougher questions of the students: What exactly am I looking at here? What is this thing on the bottom left supposed to be? Wouldn't it make more sense to move this character over to the right? Why use the fancy "camera" angle here when it makes the image impossible to decipher? How about adding some solid black areas to the composition so the space has greater depth and our eyes are pointed to significant parts of the composition and/or are guided through the image in a manner that makes the implied narrative more clear? Could you avoid using that sombrero as a signifier? Is that an eye on the floating man's tongue? Huh?

Exercise 2.1
First, a short writing exercise. You will need a stack of index cards (say, $3^{1}/_{2}$ x 5 inches or larger). Cut a handful of the index cards in half. On these half cards write: something you overheard recently in a public place, something you said to someone earlier that day, a catch phrase or slogan, a question of some kind, and maybe an interjection. Set these aside, and we will return to them at the very end of the class.

* * *

Exercise 2.2

Use the pen or pencil of your choice. On the full-size index cards, draw the following (one image per card, no words allowed): the funniest thing you can think of, the saddest thing in the world, something sexy, something abstract, something scary, something boring or mundane, something you saw earlier today, and something you saw in a dream recently. Now spread these 7 cards out in front of you.

OK, I admit, the previous exercise was a trick. Get those half cards with the various sentences and phrases you wrote, and place them under the drawings (i.e., so they act as captions). Keep moving them around until the words and pictures start to "click" and elicit laughter. Experiment, play around, try unexpected combinations, randomly switch captions, and try to tweak the most humor from each drawing; there are usually startling juxtapositions. Note that the "funny" drawing is not necessarily the funniest drawing, and that irony works when there is a tension of opposites. Sometimes we can convey an emotion without necessarily starting from that point. Surprising, even unintended, things happen when we combine words and pictures.

Exercise 2.3

Take the set of 12 objects that you gathered up during the week, and analyze what element they have in common. Do they perhaps have more than just that one element in common? Now, remove 2 of the objects that you feel are the weakest links in the set—i.e., the 2 that have the least in common with all the others. Think about why this now feels like the most cohesive, unified set to you.

Exercise 2.4

Let us see if, together, we can adapt an entire book into a one-panel cartoon, conveying the feeling, tone, and plot as concisely as possible, challenging ourselves to elicit the maximum amount of information with a minimum number of lines. We shall use the J.D. Salinger classic, *The Catcher*

in the Rye, as there are fortunately no visual references (i.e., films, photos, etc.) for this book, allowing us to translate it and capture its essence freely, without the fuss and clutter of previously received images.

Let us start with a character, the main character: Holden Caulfield. We sketch his head: a simple circle, nose, and eye. He is sullen, so we add the appropriately directed eyebrow. He has a hat, right? Not just any hat, a duck hunter's cap, which is actually important in the story: to Holden, it sets him apart from the run-of-the-mill, identifies him as "different." Hey, we can also show his attitude by his walk: he is sullen, so he should be kind of stooped over. Body language powerfully communicates mood, and note that posture is important to character development, even in one panel.

Where is he walking? Hmm... in the city. Not just any city: New York City. So maybe we draw an abstracted Empire State Building in the background. Now, what time of year is it? Winter, so we draw some snow on the ground; maybe some flurries in the air? Better yet, how about just a bare tree in the background? Note that snow takes up more graphic space, thus potentially distracting us from the main point, perhaps even competing with it. The story is not really "about" snow, but we need to evoke the season, out of loyalty to the narrative and its tone.

Is it day or night? Let us choose daytime, which is a little easier to draw, anyway. If it is nighttime, we run into the problem of how to ink, say, black hair against a black sky. This is a perennial cartooning conundrum. One solution is to draw a white "halo" around the black foreground shapes that abut the black background. Well, we need not bog ourselves down with this issue just yet. Let us soldier on and keep moving forward.

Holden is out of step with humanity, so we might draw a group of people in the composition. This also intensifies the feeling of his isolation. It seems apt that he should be the dominant figure in the cartoon, since the book is a first-person narrative from his point of view. To reflect the book, the cartoon should also help us empathize with him. To that end, note that he is walking in the same direction as the flow of our reading (left to right), while the other people are walking against the flow.

How many people should we draw in the background? One other person? Well, that doesn't feel like "people" walking in the city, does it? It implies a pretty desolate, abandoned street, which is not what we want. We could draw two people in the background, but this implies a pair, or opposition (a polarity); no, two is too specific, and our minds will automatically connect or "relate" the two people somehow. How about... three! Now, that implies a group. Three is just enough to tell us, simply, "people"; besides, four or more would just make the composition too cluttered.

Since the book is entirely Holden's narration, and we get to know him through his words, maybe he should be saying something here. How would we know he is the one talking? Well, we can use a word balloon (but its "tail" would be too vulgar and intrusive in this composition) or a thought balloon (too clownish and broad here, no?). How about a caption, with quotation marks? That seems nice, because it could suggest both speech and an internal monologue. We could also have something in the composition that directs our eye toward Holden—some lines, or even an arrangement of lights and darks, that lead our eye right to him. And we will draw a mouth on him but not on the other characters, how about that?

Note also that he occupies (roughly) the center of the space, which helps us focus our eyes on him. But we do not place him directly into the exact center, which would kind of deaden the composition and any sense of movement or visual interest. Sometimes a border around the image seems too definite, too overbearing. We could keep the composition open but not amorphous, and thus only imply the circle. However, the circle visually "rhymes" with Holden's head and makes for a nice, airtight overall structure; it creates the sense of a self-enclosed world inside the character's head, which mirrors the book's monologue.

What is he saying? How do we sum up the essence of Holden Caulfield? "What a bunch of phonies!" or maybe "Buncha phonies!" Hmm... getting there. "Phonies! Phonies! Phonies! Phonies!" Nah, I don't like the exclamation point; it's too emphatic and overstated. "Phonies, phonies, phonies, phonies." Or, how about the simplest, most elegant solution? "Phonies." I think we have a winner.

* * *

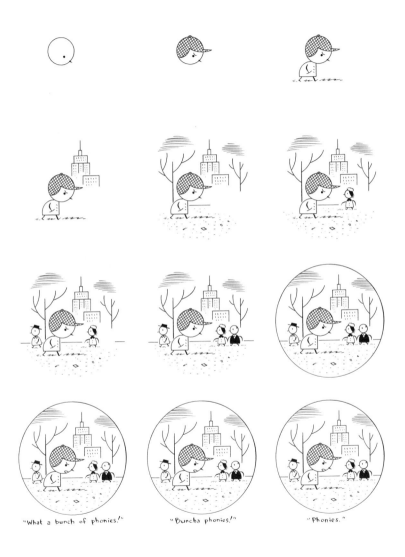

Figure 2.1. *The Catcher in the Rye* as a single-panel cartoon.

HOMEWORK ASSIGNMENT 2

Create 3 single-panel cartoons, in black and white. Pay special attention to calligraphy (your line quality) and composition. Place the action in an identifiable location or space (e.g., a bedroom, the White House, a playground, a bus stop, a Chinese restaurant, the planet Mars, etc.). Pay attention to the placement of solid black areas, if any, and how they "move" your eyes through the image. The panels can be wordless if you wish. If there is a speaker, make sure there is only one per cartoon. Strive for clarity of narrative content, both words and image. Avoid using words inside the panel; try to use words only in the caption. You are by no means required to typeset the captions, but make sure your writing is legible.

Photocopy or scan and print the cartoons. It is OK to use one, two, or three sheets of paper (whatever final size you think fits your work best). Pay close attention to what happens to your original artwork when it is reproduced. Do lines disappear or clump together into indistinct masses? Are there any extraneous marks that do not clarify the narrative, individuate the characters, or delineate the space, and thus can be removed?

Do not worry about being "funny." Take inspiration from the everyday things you see and hear, let your mind and hand wander, and/or use some of the techniques we learned from the exercises: randomly switch captions from one cartoon to the other, tone down the captions for the outrageous images and vice versa, underplay rather than overplay the emotions, try to capture a real reaction someone might have to a strange situation, use a common phrase in an unlikely circumstance, think in terms of verbs (i.e., what is *happening* in the panel), embrace ideas that emerge from or are suggested by accidents or mindless doodles, start by drawing something intentionally "not funny," abandon troublesome notions such as "making a statement" or "being profound," do not be afraid to end up somewhere very far from where you started, and try to make the single panel tell a comprehensible little story.

Simplicity, clarity, and elegance are the goals.

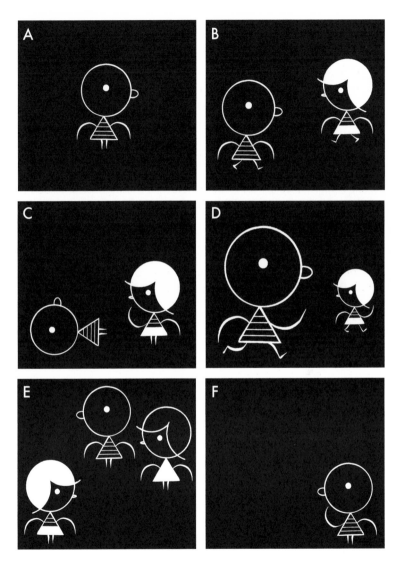

Figure 2.2. Some basic compositional ideas: **A** boring, **B** interesting, **C** still, **D** active, **E** crowded, and **F** empty.

FOUR-PANEL STRIPS

Not unlike the marks that form letters and words, we can also think of the lines of our drawing as having a "sound"; they can be cacophonous, flow melodiously, or even evoke silence. Think of a thin, curved dotted line, a harshly jagged scrawl, or a thick droop of ink. Can you hear them in your head? Just as calligraphy can represent sound, so too can composition within a panel represent sound: a few horizontal and vertical lines can suggest the repose and stillness of a quiet room, while a jumble of diagonal lines can suggest an unruly, loud mob. Extrapolating from this, we see that a sequence of panels also has a sound, a rhythm, some might even say a "music." This week we will begin to think of panels in relation to each other. First, let us loosen up with a little drawing exercise.

Exercise 3.1
You will need 12 index cards and the pen/pencil of your choice. Draw one panel per card, spending no more than 3–4 minutes per card. Do not use any words. Draw the following scenarios: (A) The beginning of the world; (B) The end of the world; (C) A self-portrait, including your entire body; (D) Something that happened at lunchtime (or breakfast, if it's still morning); (E) An image from a dream you had recently; (F) Something that happened in the middle of the world's existence, i.e., between drawings A and B; (G) What happened right after that?; (H) Something that happened early this morning; (I) Something that has yet to happen; (J) Pick any of the above panels and draw something that happened immediately afterward; (K) Draw a "riff" on panel J; for example, a different perspective, another character's viewpoint, something that happened off-panel, or a close-up on some detail or aspect of the drawing; (L) Finally, draw something that

has absolutely nothing to do with anything else you have drawn in the other panels.

Spread the 12 panels out in front of you. Try to create a comic strip by choosing 4 of the panels in any order. Mix and match them however you wish. Observe how the emotional rhythm or "timing" changes when panels are rearranged. Choose a four-panel sequence that "reads" best to you. Think about why that might be. What kind of narrative do you prefer? Do the panels flow seamlessly? Are there visual elements that clearly connect one panel to the next? Do you see any abrupt breaks in the narrative? What about re-ordering the strip so that it reads in the opposite direction? Experiment with as many different narratives as you can muster. Pay attention to what happens to the story when the point of view changes or the scale shifts. Note how easy it is to completely change the intent or meaning of the strip by substituting or moving even one panel.

Paradoxically, the haiku-like rigidity of the four-panel structure allows us quite a flexible starting point.

Exercise 3.2
Gather up the 10 similarly themed objects from last week's homework. Put the objects in some sort of order, or arrangement. Start putting objects next to each other, and let the overall structure slowly suggest itself. Perhaps you can arrange them by size, or color, or both size and color, or from simplicity to complexity. Do the objects tell a story of some kind? Or are they more conceptually arranged? Is there a discernible order or direction to them? Where is the starting point and where is the ending point? Or are we to experience the set as a singular totality? Perhaps both? Why did one particular object intuitively "fit" next to the other? Are there subsets within the larger set? As you play around with the arrangement, note that what you are doing is essentially making it "readable."

HOMEWORK ASSIGNMENT 3
Let me first state that James Kochalka must be given credit for this brilliant idea. Using your sketchbook as a diary, draw one four-panel strip per day.

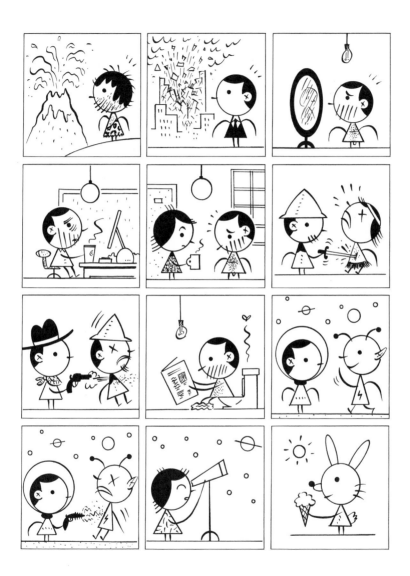

Figure 3. Sample drawings for today's exercise.

You should have 6 "daily strips" by the time of next week's lesson. Identify or title each strip with the date. The strips can be drawn loosely, but make sure they are clear and legible. Aim for honesty first and foremost, but also take some care to consider graphic simplicity, clarity, and consistency. Try to make the little four-panel stories come alive on the page. Important: Use only 4 panels per day, with each panel being of equal size. Black and white. Yes, it is OK to use words.

Try to fit all your strips onto one $8^1/_2$ x 11 inch page (after reducing your originals, of course). If that is not readable, then reproduce the strips onto two or three sheets of paper (meaning you will not have to reduce your work as small). Do not worry about being "funny." Avoid it, even. You can take inspiration from everyday things in your life: observations, anecdotes, dreams, meandering thoughts, or whatever strikes your fancy. Limit yourself to only one "I couldn't think of what to draw today" strip, if you must resort to it.

A SIMPLE PAGE

Some of the more impatient students are probably itching to start drawing pages with fancy layouts, characters bursting out of the panels, word balloons shaped like icicles, diagonal borders, and the like. Yet, at this early stage, the serious student would best focus on capturing the nuances of rhythm, movement, character, and gesture before attempting to dazzle us with cleverness, pyrotechnics, or showboating. As in Ovid's famous dictum, "True Art is to Conceal Art."

In the following exercise, we will again be working without words. I understand these "silent" comics might be frustrating for you; allow me to explain. We are not working without words as some sort of stylistic or formal experiment. This sort of fetishistic thinking leads us nowhere and often results in what I call "variations without a theme." We are working without words so that we notice the "sound" inherent in line and composition, thus teaching us to eliminate all that is extraneous.

As kids, we may have seen those "how to cartoon" books wherein characters emote with grossly exaggerated gestures and facial tics. If we are to aim for subtlety and complexity, we must "turn down the volume" and discern how much can be communicated before we add the extra layer of words. It is no great trick to draw whispers or screams; a dotted word balloon or oversized letters will do the trick. It is the vast gray area of in-between volumes that is more difficult to convey. Even the way a character stands or walks can be overstated, seeming shrill and too theatric. And a flashy page layout inappropriate to the actual content can be as annoyingly piercing as a siren.

* * *

Exercise 4.1

In your sketchbook, draw a character built out of simple shapes: circles, triangles, rectangles. Minimal features and rudimentary limbs are OK, as is a basic pattern on his or her clothing. Roughly sketch the character in a few poses: side view, front view, moving, at rest, etc. Then sketch a location. Now draw an object, item, thing, or prop (whatever comes to mind). Finally, think of a verb, an action, for your subject.

Using 4 index cards of equal size, draw a four-panel strip, without words, of your character, in the location you chose, performing that action, making sure to somehow incorporate the object. Make this action, this sequence, clear. Hint: try not to shift the point of view or the scale, unless the narrative dictates that we need to see the action, say, close-up or at a different angle. Another hint: pay attention to the edges and corners of the index cards, and give your character adequate space to exist and act.

If I may make a suggestion: try orienting your index card horizontally instead of vertically. "Going wide" has two immediate benefits. First, it more closely approximates our eyes' field of view and (perhaps not coincidentally) correlates with the proscenium's compositional space, seen not only in stage plays but also on film and computer screens. Second, it damningly highlights those unconsidered compositions that focus on the figure to the detriment of any surrounding environment. We've all seen examples: a character is cut off at the ankles and surrounded at the top, left, and right by an undeliberate emptiness, a vast halo of nothing, a rickety non-space, or what I call The Arch of Uninterestingness.

You will probably notice that if your short strip necessitates the character making a decision, it becomes a challenge to convey that information wordlessly. Any story in which the reader needs to be inside the character's head to understand a choice or motivation is much more difficult to convey purely visually.

Draw 2 more panels to make the motivation behind the character's action clearer. Then, draw 2 more panels that show some consequence of the action depicted. You can insert these additional panels wherever needed, with the aim of finding the story's inherent structure, as opposed

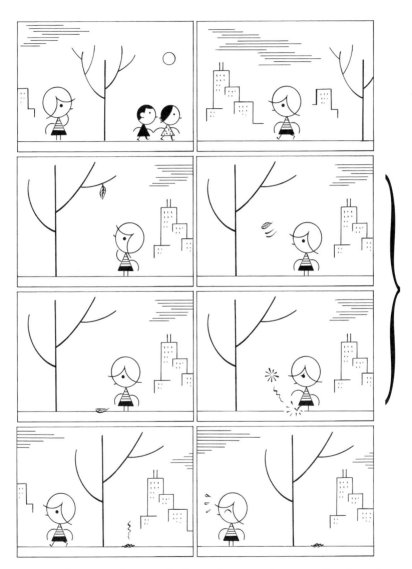

Figure 4. Working out a simple sequence. The four-panel sequence in the center was drawn first, and the top and bottom panels were added afterward.

to an arbitrary beginning, middle, and end. In the end, you should have a simple but comprehensible narrative. Stack up the 8 panels in 4 rows, and you have created a simple page layout.

Exercise 4.2
Compare the above process with last week's exercise arranging the 10 objects. Note that in both cases we were, at heart, designing. We considered not only the shape of each object, but also the relationship of each shape in the overall arrangement, or composition. Through constant practice and awareness of these principles, we develop visual sophistication.

HOMEWORK ASSIGNMENT 4
Again using your sketchbook as a diary or journal, create a 6–9 panel strip that fits on one 8½ x 11 inch sheet of paper. The panels should all be the same size. Black and white. As always, you can draw your original at a larger size and simply use a photocopier to reduce the image to fit the sheet of paper.

The subject matter is up to you, but take care to observe the world around you, the way people speak as well as their body language; pay attention also to your "internal" world and the flux of your thoughts and emotions. You do not have to consciously try to sum up your entire day or week, or convince us of your pithiness. Recreate a brief moment of life, transcribe it, on the page.

WEEK 5

THE DEMOCRATIC GRID

By "democratic," I am referring to a grid of panels that are all exactly the same size, from which we can infer their equal weight and value in the "grand scheme" of the page. We can also think of this type of grid as an invisible template; it does not call immediate attention to itself, but invites us to an unimpeded narrative flow, acting as a living "calendar" of events, sweeping or microscopic. The democratic grid need not be uninteresting or undistinguished; with a spirited approach, it can be the apotheosis of elegance, simplicity, and sophistication.

We humans intuitively divide our existence into "evenly spaced" units of time (not coincidentally, these are rooted in the cyclical patterns we see in nature: in the night sky, the tides, birth and death, our very heartbeats). At the same time, these units are constructions of our minds. Is there really a division between one moment and the next, independent of our perception (and therefore conception)? Is life not in a constant, ineffable flux? Any given instant is the effect of all that has come before it and simultaneously the cause of all that will come after it. We can no more separate the two than we can come up with an absolute dividing line between "order" and "chaos." Is there a threshold point where the random becomes orderly, or vice versa?

We experience the comics page both as a whole and as a sum of its parts; moreover, "form" and "content" are not just inseparable, but actually originate interdependently. If we share an anecdote with someone, the minute we begin to tell the story we have content, and at the same time we have form (even if sloppy or incomplete), i.e., that which we perceive as an "anecdote." The biggest mistake we can make is to separate form from content. We are then left not with comics, but with illustrated text. Worse

yet, we might be grafting a macabrely severed face onto another being's malformed visage, or trying to play a Deep Purple song on a spinet piano.

Thus far, we have been limiting ourselves to drawing panels of the exact same size, so that we may strengthen our ability to compose, always being aware of the "frame," the edges of the panel (and by extrapolation, the page). The panel is content is form is a rose is a rose.

Exercise 5

Start at the top left corner of your sketchbook page. Draw a simple head in profile (include only an eye and nose). Moving slightly to the right, draw the same head again, but with the addition of an eyebrow. Again move to the right, drawing the same head (same size) with the same eyebrow. Do this without thinking too much, and draw quickly. Keep moving rightward, drawing that same head, same eyebrow. When you get to the rightmost edge, start another tier and repeat the process. But now gradually allow yourself to vary the eyebrow from head to head. Try many different eyebrows. Let the previous eyebrow suggest the next one. Every so often, try again to draw a series of heads with the same eyebrow. Then go back to varying the eyebrows. You will eventually have an entire page full of simple heads expressing a sequence of emotions.

Note that minute shifts in the eyebrows, whether or not intentional, subtly alter the emotion expressed. More importantly, note that even without drawing one, a democratic grid is implied. It is the natural inclination of the mind to seek order and structure. Note also that a "story" is suggested. Here we are seeing the cartooning language in its simplest form: we are "reading" the pictures.

HOMEWORK ASSIGNMENT 5

Draw a simple page, using 12, 15, 16, or 24 panels of equal size. Black and white. You may draw the original at any size, but make a photocopy and reduce it to $8^1/_2 \times 11$ inches. Optional: include a title, drawn by hand (do not typeset it). If you decide to use a title, place it outside the grid of panels (i.e., at the top, bottom, or side of the strip).

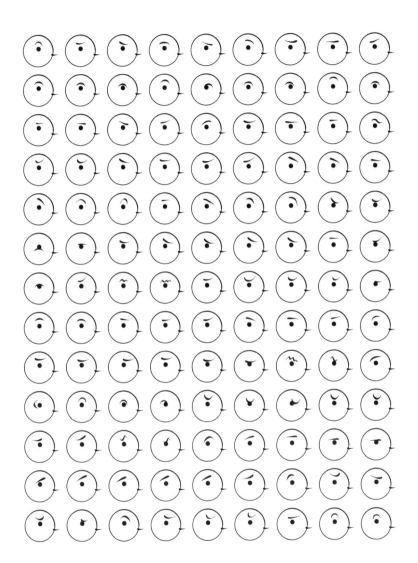

Figure 5. The "eyebrow-to-eyebrow" transition, an idea shamelessly stolen from Chris Ware.

The subject of this week's assignment is something with which we all have experience: childhood. The story can be fictional, but base it on experience and observation. To get started, doodle in your sketchbook, or write a few words. What is the first thing that comes to mind when you hear "childhood story"?

Perhaps you can begin by drawing your old bedroom. We can remember a surprising amount of detail once we let our minds wander. Was there a television in the living room? What was a typical dinner like? Did you have a favorite toy? Was there a playground at your school? What did the classroom look like? Or feel like? Can you see your old desk? A house you walked past every day? A pet? Your friends? Enemies?

Quite often, a story takes shape by visualizing a place, maybe a room, and someone in that place. Then a sound, a smell, or an emotion. Start with one strong image and move from there: forward, backward, wherever that image takes you.

THE HIERARCHICAL GRID

We can liken drawing a comic to creating a miniature reality on the page, or, as Chris Ware has said, "dreaming on paper." Let us consider the dream: is it autobiography or fiction? On the one hand, dreams are leaps of imagination, evidence of the plasticity of the information stored in your brain, recombining in sometimes fantastic, startling ways that you could never imagine in waking life—thus a form of fiction. At the same time, that fiction could come only from your own particular brain and the stimuli it has processed and retained. Every character in your dream is basically... you. Or an extension of you. The dream is all about you, its unconscious author. In the end, autobiography and fiction are not a dichotomy but a polarity, a continual tug and pull that can never be precisely pinned down and measured.

A comics page reflects the way the author remembers his own experience of reality, the flow of time, the importance of people, places, and things. In comics, the number and relative sizes of panels, the scale and density of the information within the panels, any shifts in the viewing angle, even words themselves are simultaneously visual and literary tools. Think deeply about the concepts of "relative size," "shifting scale," and "point of view," for in comics they are both literal (drawing-wise) and figurative (writing-wise) and thus an inextricable part of the narrative rhythm. We must take care not to jar the reader out of the narrative, inadvertently severing the reader's identification or empathy with the character(s) or story.

The architecture of the comics page can be austere yet playful; it can draw us in or keep us at a distance. Once we begin reading, the panels walk us through the structure deliberately, at a certain pace. Furthermore, as with moments in time, each panel exists, in a latent state, in all the other

panels—a mutually inclusive whole. As we shall see, there is no great mystery involved in page layout, only common sense. But first, an exercise.

Exercise 6.1
This is mostly a thought exercise, but you should write down your impressions in your sketchbook and perhaps even make some sketches if you are so inclined. Bear with me, and relax; there are no wrong answers here, only dishonest ones.

Imagine you are walking in the desert. Can you see it in your mind? OK, now, after walking for a while, you come upon a cube. Describe that cube.

Suggestions: How big is it? What is it made of? Is it hollow or solid? Is it on the ground or floating? A part of the desert or detached from it? How do you think it got there? What is your impression of it? What are your feelings about it, if any? Do you touch it? Can you hold it? Do you? Is it impenetrable? How does the desert affect it? Are there any openings? Is it large enough that you can go inside it? Do you? Do you interact with it in some way? Record your feelings about the cube. Why do you think you reacted to it as you did? Are you able to discern its history and makeup, and if so, how? Do you care? How do you think most people would react to it if they saw it? Can anyone other than you even see it? And so on.

Record anything you can about this cube and the impressions it conjures up within you.

Exercise 6.2
Figure 6 shows a comic strip of the author's cube. Note that the decisions made in the layout of the page imply a sort of "hierarchy" to the panels and their flow. While a democratic grid could suggest a sort of invisible structure, perhaps even objectivity (if such a thing exists), a hierarchical grid asserts itself, introducing new levels of narrative complexity. Used carelessly, it lumbers or pompously swaggers and huffs, oblivious, insensate, and irrelevant; used with consideration, it radiates dignity and generosity of spirit and communes—empathizes, even—with the reader.

Layout is staging, and it follows narrative function. A larger panel accommodates more space and possibly detail. A close-up focuses on and emphasizes something important to the narrative (e.g., a facial expression). A downward view is used when we need to see something interesting

Figure 6. The author unwittingly reveals himself. When we describe the cube, we really are talking about ourselves, how we see ourselves, how we feel about ourselves: the size of our ego, level of detachment, relationship to our environment, etc. Any disingenuousness is tantamount to lying to ourselves; in the end, we all have to "face our inner cube."

or important from "above." A series of smaller panels can slow down time, while a series of thin, narrow panels can create a rushed sense of fragmentation. Small, cramped panels can feel claustrophobic or myopic, while large, open panels can feel expansive, more "aware" of a larger world. And so on. But note that all of these expectations can be flipped for a sense of tension or disorientation.

HOMEWORK ASSIGNMENT 6

Draw a one-page story, with any layout and any number of panels, as long as there is at least some variation in panel size. Include a title. Reduce the original to 8 1/2 x 11 inches. Black and white.

This time, the story should be about a relationship, or relationships (yes, in the "romantic" sense). It could be about the beginning, middle, or end of a relationship (or all three), the lack of a relationship, a crush or unrequited love, a fantasy, a speculation, an anecdote about a past or current relationship, your general musings on "love," or anything along these lines. As always, use your own experiences and observations (or even a story someone told you) as a starting point, taking the narrative in whatever direction you wish.

WEEK 7

TOOLS

Intelligence, thoughtfulness, and sensitivity make an artist—not the blithe, confident application of brushstrokes. We master our tools so that we can tell our stories, navigating our way through self-doubt as we stumble and search for truth, not so that we can extrovertedly make our pens "sing." The depth of an artist's intellect and perceptiveness is always evident in his drawing, but not so much in the surface qualities (the "prettiness" of the art) as in the compositional solidity and the sum total of thought and experience that informs each line, no matter how spontaneous or rough.

Never rest on your innate talent, for it is only a starting point. Whenever you finish a page, step back from it and ask yourself if it would perhaps be even better if you spent an additional hour or two on it, bringing out its fullest potential. By the same token, you will want to bring out the full potential of every single tool at your disposal: not only the pens and brushes, but also the paper.

Yes, the blank page is itself a tool. Note its corners; is it any coincidence that we instinctively draw rectangular panels? Perhaps they are iterations in miniature, mirroring the shape of the containing page. The panel "grid" likely evolved as an intuitive outflow from the very nature of the blank page. The corners of the page are themselves defined, or delineated, by yet another overarching structure: the outside world surrounding that page, i.e., life. All is part of an inextricable, interdependent whole, and the comics page is a powerful (if necessarily incomplete) metaphorical representation of this wholeness.

Our dedication—devotion—to craft should enlighten as it humbles us.

* * *

Exercise 7

You will need a brush, a dip pen, a technical pen (fountain pen or marker are OK), and an 11 x 17 inch sheet of paper; I would recommend something sturdy, i.e., some type of board.

First, however, doodle in your sketchbook for 15–20 minutes, exploring the pens and brush, familiarizing yourself with and embracing their idiosyncrasies. Then, switch to the 11 x 17 board. Using either a pencil or a pen, rule out a grid of 10 x 16 squares (1 inch each); leave a $^1/_2$ inch margin all the way around the paper.

Fill each square with one type of mark, pattern, or texture made by one tool (hatches, stipples, blotches, anything you can think of). Use all three tools on the page, and feel free to incorporate as many additional tools or techniques as you wish. Explore any and all possibilities. In the end, you will have a grid or "chart" of 160 marks made by the various tools.

Use this exercise as a method of gaining insight into your own temperament. Did you fill the squares randomly or methodically? Did you move around the board freely, or approach the squares in order, left to right, top to bottom? Or perhaps you subdivided the grid into distinct areas to showcase each tool, maybe duplicating the same set of patterns with each tool, for a near-scientific comparison.

Try to discern if there is a "flow" between squares, from tier to tier and column to column. Do some sections cohere, forming their own subgroups? Analyze how our eyes move through the overall grid: do they jump around, rest on a particular area, immediately pull toward a particular point? Note the variations of ink density, the spectrum of contrasts. Think about how curved lines suggest movement, perpendicular lines imply repose, and diagonal lines assert direction. Compare the "organic" versus the rectilinear qualities of the marks, and any interesting juxtapositions.

Using a photocopier, reduce the page to 65 percent, 50 percent, and 35 percent of its original size. Most students are surprised that the smaller reproductions often look best. Making photocopies of our originals is quite instructional, because we get a clue as to how our work will look

Figure 7. One of countless possibilities for a grid of marks.

when reproduced and how to "size" our artwork by considering the final reproduction as we create our originals. We may need to adjust and clarify our drawing if our lines do not reproduce as intended.

Avoid frills or unnecessarily elaborate flourishes; simplify your range of gray tones. As Art Spiegelman wrote in *Dead Dick*, his Dick Tracy homage, "Never stipple when you can hatch. Better yet, use black."

HOMEWORK ASSIGNMENT 7

Choose one of your favorite comics pages, either black and white or color. Analyze why the page is special to you, what you like about it. Think about what tools and techniques the artist may have used, and venture some guess as to the size of the original artwork. Choose also one of your least favorite pages, by a least favorite artist. As above, analyze what makes it so.

Bring both pages (or good-quality photocopies or printouts) to next week's lesson. Write a short essay (say, 300–500 words) comparing the two pages.

STYLE

Last week, we experienced firsthand how each tool naturally guides us toward the particular set of marks for which it is best suited. We need not slavishly and laboriously imitate the surface effects of one tool by forcing them out of another. After many failures, we will develop empathy for our tools and discover their intended purpose, and soon enough they will begin to "behave" appropriately. As Jim Woodring once said, "Craft is control." Control is a consequence of your firm but loving hand; it develops best with practice, without obtrusion. Remember, it is a poor craftsman who blames his tools.

The same is true of style: we must not force it upon our artwork, but rather let it grow of its own volition, from the totality of our influences and abilities (or inabilities, as the case may be). When style is not the natural outcome, the outgrowth, of all these things, we have instead a repugnant, off-putting mannerism. Many beginners, sadly, approach the whole matter "bass-ackwards." They fret about style long before they master some reasonable drawing ability, learn to handle the tools of the trade, intuit the basics of design and composition, or (worst of all) eliminate affectation and dishonesty from their stories. They also tend to obsess over wrong-headed concerns, like "networking" or "marketing themselves" or (ugh!) "knowing the right people" in order to get their work published, and they begrudge the "success" of others, never turning their supposedly discerning gaze toward their own work.

Here is Saul Steinberg talking about the skilled carpenter Sig Lomaky: "When he needed a piece of wood for some job, he chose it carefully, looking at it as though asking who it was, examined its grain, and looked

for suggestions from the wood itself. For me it was a lesson to be taken as a rule of life: never do things by chance, never exaggerate needlessly, as when one gives too much importance to a person, or too much love, or an excessive tip."

Exercise 8

Now let us examine those most favorite and least favorite pages you chose; for the sake of conversation, I will refer to these pages and their respective artists as the "good" and the "bad" (though I realize this may be quite an oversimplification). I hope that writing the essay sharpened your analytical skills and helped you look at the pages in a new way. Compare again the "good" and "bad" pages: do they perhaps share any qualities in common? Examine not just the drawings and compositions, but also the content and intent of the narratives.

In your sketchbook, redraw a panel by the "bad" artist, but mimic the style of the "good" artist; conversely, redraw a panel by the "good" artist, but mimic the style of the "bad" artist. In the first instance, one naturally expects to see improvements to the image, but now challenge yourself also to take something positive from the "bad" artist.

Could something done "badly" actually be used as an expressive tool by the "good" artist? For instance, might an off-kilter composition, stiffness in the poses, or an awkwardness in the narrative flow be used intentionally, and for a "good" cause? Sometimes even the "bad" artist's work may have an energy, power, or forthrightness that may be absent in the work of the "good" artist. In rare cases, we may even grow to love the work we once dismissed with a visceral hatred.

As you blend the sensibilities of the two artists, note the commonalities between both of the panels that are "of your own hand." Use this exercise as an insight into the qualities that define and distinguish your own work. We all begin by imitating the styles of our favorite cartoonists, much like apprentices observing a master. Your own work will likely be derivative for quite some time; constant practice, however, will make your work unique.

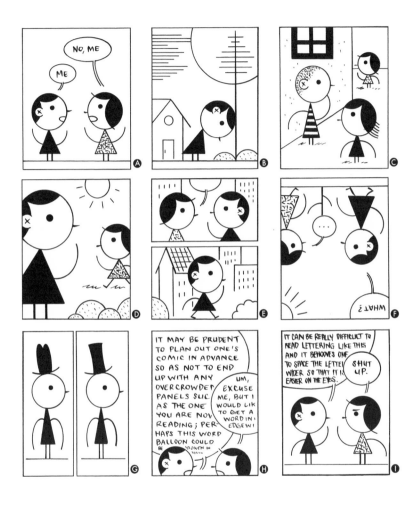

Figure 8. Some common pitfalls. Note, however, that all of these can be subverted and used to the artist's (and narrative's) advantage. **A** Who is talking first? **B** Spatially confusing tangents. **C** Clunky perspective. **D** Arbitrary framing. **E** Unintentional connections. **F** Awkward compositions, more easily seen if page is upside down. **G** Inconsistent character design. **H** Not enough space. **I** Lettering too small or close together.

In 1908, Paul Klee wrote in his diary: "He has found his style, when he cannot do otherwise, i.e., cannot do something else."

HOMEWORK ASSIGNMENT 8

To the absolute best of your ability, create an exact replica of your favorite page. Do not trace. Any deviation from the original should be unintentional on your part; ineptitude and sloppiness are charmless when deliberate.

Pay close attention to what you are copying. Think about the artist's decisions regarding page layout, panel compositions, design, characterization, dialogue, gesture, captions, balloons, word placement, sound effects, line, shape, texture, etc. Hopefully you will gain some appreciation of their working and thinking process... and the difficulty of creating a comics page.

You may want to draw at a larger size than the printed version you are replicating. If so, make a reduced photocopy (or printout) of your artwork, to match the size of the printed book. You are not required to use the same tools or techniques the artist used, but be aware that emulating these may actually turn out to be the path of least resistance.

Thoroughly acquaint yourself with every detail of the page you are copying, and chew on this bit of advice from Daniel Clowes: "Think of the comic panel (or page, or story) as a living mechanism with, for example, the text representing the brain (the internal; ideas, religion) and the pictures representing the body (the external; biology, etc.), brought to life by the almost tangible spark created by the perfect juxtaposition of panels in sequence."

A FULL-COLOR "SUNDAY" PAGE

The Sunday newspaper comic strips of the first half of the 20th century, printed in color and oversized, provided ample "canvases" for cartoonists to incorporate ornamental designs, ancillary strips featuring minor (or entirely separate) characters from the main narrative, even meditative meta-panels—all interlocked in the overall page structure.

As an integral part of the whole, color can solidify spaces, harmonize compositions, or strike necessary discordant notes; it is yet another expressive tool at the cartoonist's disposal. Color, according to Goethe, is not a static quantity, but the interchange of light and shadow, or "a degree of darkness, allied to shadow." You may have wondered why the previous lessons specifically forbade the use of color. Well, actually, we have been using two colors all along: black and white. Not only that, the interplay of black and white—whether through texture, shape, or line density—forms also gray. Therefore, we really have been learning to arrange and balance three colors: black, white, and gray. And the overall distribution of the three can be thought of as yet another level of color (the "meta"-gray?).

If I may go out on a limb: as we have been telling our stories, we have been figuratively "coloring" them with an emotional tone. The composition of a page affects its overall "feel," thus "coloring our view" before we even begin reading the panels. The same could be said of a title, which may lead us to expect humor or seriousness, or may be purposefully challenging, vague, mysterious, open to interpretation. Thinking back to *The Catcher in the Rye*, consider that Holden Caulfield actually misremembers the line from the Robert Burns poem that provides the novel's title. This is explicitly stated in the narrative (recall Holden's conversation with his sister Phoebe). Could the distortion implicit in the title, then, not only sum

up the themes of the book, but also underscore the author's identification with Holden? Well, we can save these debates for Literature class, but the main point is that the title is important; it "colors" the entire narrative from the outset.

Exercise 9

This is not so much an exercise as a brief overview of some of the approaches we can take with color; you may do well to flip through a variety of comic books and study them with a magnifying glass, noting how some colors are created by a combination of tiny dots (i.e., the halftone screens). We do not have adequate space to explain the history of printing, but some research into this area would help any cartoonist. I would note here only that the method used by an inkjet or laser printer is very different from offset printing, which is what is generally used in comics, whether it be the standard four-color process (a.k.a. "CMYK" or simply "process"), or the use of spot colors (a.k.a. "Pantone" or "PMS" colors). Basically, cartoonists have to think like printmakers when they use color. See Figure 9.

Advances in computer technology have made scanners inexpensive, so it is quite easy to plop down our artwork, click "Scan," and do a "Save As..." without understanding exactly how the printing process works. Well, that image will eventually be separated into four printing plates, one each for cyan, magenta, yellow, and black (the aforementioned CMYK). Note that "K" refers to black; this is because it denotes the "key" or "keyline" image. Black was and still usually is what we use to "register" the image, the key that unlocks the image's puzzle, so to speak. This is most obvious in comics, especially those old Sunday strips, with their black lines "trapping" most if not all the other shapes (i.e., colors).

I promised some scanning tips way back in the Syllabus. High-contrast, black-and-white line art: scan at 1200 dpi bitmap. Lower contrast black-and-white art, with gradations in tone: scan at 600 dpi grayscale. Color: scan at 300 dpi. Needless to add, the computer offers myriad ways to achieve our printing goals and add an endless variety of subtle and not-so-subtle effects. You will have plenty of time in your life to explore the

Figure 9. On a black-and-white page, we can still achieve "coloristic" effects in a number of ways: **A** with the overall gray formed by the white space and the contrasting line density, **B** by the distribution of solid black-and-white masses, and **C** through the use of textures and patterns, such as hatching. **D** For color pages, we can indicate the areas to be printed with another color ink (or "spot" color) by, say, drawing another layer to be used as a separate printing plate. **E** We can also choose to separate the black layer from the other colors; in the four-color process, this has the advantage of producing a sharp, high-resolution black, while the other color combinations are mechanically "screened" onto separate plates. We can only simulate the effect here. **F** If we apply the color directly onto our ink drawing or eschew line altogether, we can then scan it as one layer; however, by doing so, we retain subtler tonal gradations but sacrifice sharpness.

Photoshop manual; at this stage, worry mostly about composing with color, not the "tech" stuff.

HOMEWORK ASSIGNMENT 9

Draw a one-page story, using any layout and any number of panels that you wish. The final size should be 11 x 17 inches, even if reduced. Either horizontal or vertical format is OK. Include a title in the composition, and consider using some subordinate elements as described in the first paragraph of this chapter, perhaps adding a sub-narrative, another "layer," or a contrasting note or aspect to the narrative. Not counting black, white, and gray, use at least one other color. Use as many additional colors as you like, and apply the color(s) with whichever tools you feel comfortable.

Colors can represent emotional states as well as external phenomena, so let us create a story about... the seasons. You can pick just one of the seasons, something about the change of seasons, or whatever the word "seasons" evokes to you. Suggestions: capture a mood, a time, a transformation. If all else fails, write about today's weather. What color is the sky right now? What does the air smell like? Is there a powerful memory that you associate with a specific time of year? Visualize it, and go from there.

It can be a fictional or autobiographical story.

WEEKS 10 THROUGH 14

A FOUR-PAGE STORY

And so, we arrive at our last assignment: a story of four pages in length, on any subject, drawn in any dimension, in black and white or in color, using any tools or techniques, with any layout you wish. This will give you the opportunity to consider the center "spread" as a potential composition, and the story as a whole as yet another level to the composition. The story could be fiction, non-fiction, biography, autobiography, journalism, or a genre of your own invention. Allow yourself 5 weeks of work for this final project. The challenge will be to divide the labor into some manageable schedule; this will depend not only on the tools and media but also on your temperament and ability to multi-task.

For instance, you may improvise one panel at a time, fully penciling and inking it, before moving to the next one, without any worked-out plan beforehand (I read somewhere that this is how Robert Crumb works). You could fully write out the story first, and then draw one panel or one page at a time, but that may feel more like "illustrating text" than cartooning, and the lack of flexibility may be frustrating or uninviting. Or you can work in steps. First, rough out the pages and thumbnail the entire story; then, one page at a time, pencil, ink, and color (or perhaps color the entire story at the very end); finally, revise as necessary once you have created a full "mock-up" (either by photocopy or with a computer) that gives you an unimpeded view of the big picture.

It may be best to do more work at the penciling stage, before any inking. As boring as it may be, penciling is both writing and drawing, so it is a good place to iron out the compositions and character designs and to problem-solve issues of timing and pacing. Leave yourself some wiggle

room so that you can add little touches along the way that strengthen the narrative as a whole, change things as the evolving story dictates, and make subtle connections among various panels.

I would encourage you not to worry about establishing your ideas beforehand, and to simply work on a story that feels compelling to you, so that the themes emerge organically. Never impose or "deploy" a narrative "strategy." You may need to do research for your story, make preparatory notes and sketches, write a text summary, or fully thumbnail the whole thing down to the last word balloon. These are all good things; absorb them thoroughly, and get them out of your system. Your story will likely begin to change the second you put pencil to paper.

Chris Ware has made the best and most eloquent case for taking a "semi-improvisatory" approach. Referring to his book *Jimmy Corrigan: The Smartest Kid on Earth*, he said, "It developed organically as I worked on it; though that might sound like an excuse to improvise, it wasn't. I'd been drawing comics long enough at that point to realize that letting stories grow at their own momentum was a more natural and sympathetic way of working than carpentering them out of ideas and plans. And the images suggested the story, not the other way around. I believe that allowing one's drawings to suggest the direction of a story is comics' single greatest formal advantage."

Avoid symbolism (the imposition of an idea), but embrace metaphor (the perception of innate interconnectedness). You may need to use a rule, a constraint, a conceit, even a genre to get started. Use any of these methods not as an end unto itself, but as a means to get something down on paper. For instance, do not get lost in the minutiae of some fantastical world; that world is interesting only insofar as it allows you to approach subject matter you could not otherwise write about.

Think about the human impulse to doodle. We doodle to assuage anger, anxiety, or fear, to amuse ourselves, to soothe our sadness, to express sexual frustration, to relieve boredom, or to "detach" and meander mentally. Every doodle, every drawing, every story has some underlying

emotional basis; explore that emotion. Stay true to your original inspiration, and, if feeling mired, always go back to what attracted you to the story in the first place. You may need to reassemble your page, or even rip it to shreds. It is all part of the creative process, this koan we call "art."

Try to capture the way your mind organizes events, memories, and flights of fancy. Let the stories structure themselves, unfettered by formulas or preconceived notions. Only the most officious pedant uses an existing blueprint. A story creates its own blueprint as it unfolds. As Robert Frost put it: "No tears in the writer, no tears in the reader. No surprise for the writer, no surprise for the reader. For me the initial delight is in the surprise of remembering something I didn't know I knew."

Do not marry yourself to a structure, an idea, or even an outline. Start drawing the part of the story that you feel would be the most enjoyable. You may find yourself going in an entirely different direction than originally planned, but perhaps with a clearer conception of where you eventually want to end up. Do not fear contradictions, tangents, and digressions: these are, deep down, the things you really want to write about—and likewise will be the most interesting for others to read.

There is a wonderful moment in *The Catcher in the Rye* when Holden recalls flunking Oral Expression, a course requiring that students yell "Digression!" during the speeches if the speaker goes off topic. "That digression business got on my nerves," he explains. "I don't know. The trouble with me is, I *like* it when someone digresses. It's more interesting and all." He adds, "Oh, sure! I like somebody to stick to the point and all. But I don't like them to stick *too* much to the point. I don't know. I guess I don't like it when somebody sticks to the point *all* the time."

You may very well find that you cannot write a "continuous" narrative across the four pages. Perhaps you can, alternatively, draw a series of shorter strips—even single panels—that slowly accumulate and ultimately coalesce into one story. The pieces may even "connect" in a nonlinear way. Sometimes the more you consciously try to remove yourself as a presence from your work, the more you reveal of yourself.

The comics page abhors a vacuum. The movement of the pencil across the page will inevitably produce an image, and images will lead to other images, which in turn will create rhythms and some semblance of order, however chancy or unstable. Here's an exercise: try to create The Worst Comic Ever. It's not as easy as it sounds, in terms of form and content (i.e., simply smudging your ink or smearing cheese puffs onto your page doth not necessarily a bad comic make). As David Mamet reminded us: "It is the nature of human perception to connect unrelated images into a story, because we need to make the world make sense."

Anything perceived as a limitation of comics can actually be converted into a strength. Occasionally, students worry that their "style" keeps changing from page to page, or panel to panel; this need not be a flaw and may in fact have a certain power. Think of the frisson upon seeing the handwritten manuscript of a novel, how different those pages feel from the typeset versions. What is lost in consistency could be made up for in the directness of the author's thinking process laid bare. I am not endorsing feigned ineptitude, only suggesting that errors can lead to insight. Necessity is the mother of invention, and error its grandmother. Keep your mind open; comics need not be a dead language of word balloons and stink lines.

Charles Schulz was often asked where he got his ideas. Matter-of-factly, he explained, "Sometimes I'll just stare out my studio window for hours trying to come up with a good idea. . . . It's hard to convince people when you're just staring out of the window that you're doing the hardest work of the day. . . . But strangely enough most of my ideas come simply by sitting here at my drawing board and perhaps doodling around on this little pad of paper."

Saul Steinberg, whenever he traveled to some American town, would book a room in a Main Street hotel, stand at the window, and absorb the view; moreover, he would ride trains and buses for days, sketching architecture and observing people. Gustav Mahler spoke of a particular sensation he tried to capture in music, "The ceaseless motion and the incomprehensible bustle of life." And one 13th-century Japanese monk wrote, "Life at each moment encompasses the body and mind and the self and environment

Figure 10. The evolution of a cartoon: from a single panel, to a four-panel strip, to a simple page grid built out of short sequences, and finally to a more complex (and admittedly Ware-esque) layout.

of all sentient beings . . . as well as all insentient beings . . . including plants, sky, earth, and even the minutest particles of dust. Life at each moment permeates the entire realm of phenomena and is revealed in all phenomena."

Perhaps you have encountered someone who has been all over the world, unimpressed with it all, and has nothing interesting to say, snuffling his self-serving, self-aggrandizing tales. And then there are those of limited experience, who pile on detail after trivial detail, with no point other than hearing themselves talk. Or we have the aggressively sentimental type, willfully distorting reality just as much as the most resolutely hostile cynic. How rare is the individual whose stories are engrossing, unpredictable, attentively noticed, deeply felt, genuine, and possessing a sense of cadence—stories great and small, and somehow both at the same time.

There are infinite approaches we can take to our story. We can begin with a one-panel distillation if necessary, break it down into a four-panel sequence, and then further divide it into a longer sequence, or sequences. We can use a democratic grid as a default, switching to a hierarchical grid if we need to change panel size and dimension to accommodate more visual information or give a panel more weight. If we find ourselves unable to draw something, we can return to our very first exercise, and doodle it in 5 seconds, without thinking about it.

Always remember the famous story of Anton Chekhov, who, when asked about his compositional method, picked up an ashtray and said, "This is my compositional method. Tomorrow I will write a story called 'The Ashtray.'"

The film editor Walter Murch articulated a principle underlying the arts: "Always try to do the most with the least—with the emphasis on try." He further explained: "Suggestion is always more effective than exposition. Past a certain point, the more effort you put into wealth of detail, the more you encourage the audience to become spectators rather than participants."

The astonishing variety of work that cartoonists have managed to create with, really, the simplest of means, never fails to move me. I am reminded of Lewis Thomas ruminating on birdsong. He first describes a thrush in his backyard, who sings "liquid runs of melody," seemingly improvises sets of

variations, and forms a "meditative, questioning kind of music." He continues: "The robin sings flexible songs, containing a variety of motifs that he rearranges to his liking; the notes in each motif constitute the syntax, and the possibilities for variation produce a considerable repertoire. The meadow lark, with three hundred notes to work with, arranges these in phrases of three to six notes and elaborates fifty types of song. The nightingale has twenty-four basic songs, but gains wild variety by varying the internal arrangement of phrases and the length of pauses. The chaffinch listens to other chaffinches, and incorporates into his memory snatches of their songs."

There are no rules to cartooning (save for the ruled lines of the panels). You might write something really fast, stream-of-consciousness style, and then draw it very carefully. Or pencil quickly but ink deliberately. Or pencil tightly but ink loosely. You may aim for a dynamic look but achieve it only through tortured labor and countless revisions. You could build your drawings from furious scribbles that gradually become precise. Or draw a panel over and over again until it finally possesses just the right degree of seemingly effortless spontaneity. You could arrange organic lines into a pleasing geometry, or use rectilinear elements in an organic way. Every so often, step away from the page. Take a walk, do the dishes, sweep the floor. Return to it with unadulterated eyes.

One of the most difficult parts of being a cartoonist is being your own editor, since every line affects every other line on the page. Perhaps the single most difficult part, however, is just starting a page. One trick is to make sure you draw something, even one panel, before going to bed; it will raise your spirits and carry you over into the next day's work. Do not wait until you are "in the mood" to draw, or until you "snap out of your funk." You must force yourself to draw even if it feels joyless and pointless. You will feel better the next morning. Feeling follows behavior, not the other way around, as my therapist constantly has to remind me. Finally, both Seth and Chris Ware have told me this, and I have grudgingly come to realize that they are absolutely right: when you sit down to draw, you should "dress for work." Have respect for your craft. Put on a pair of pants.

WEEK 15

CONCLUSION

Well, how did it turn out? I hope you are satisfied with (perhaps even proud of) your final story and that you have found the course both challenging and edifying. If I have done my job, you should see a noticeable progression in your work from 15 weeks ago to now. At the same time, I also hope you can look at your work objectively and identify some areas where there is room for improvement. As Richard Taylor warned, "The mediocre eye is never able to recognize mediocrity—that's the penalty of ignorance."

Unfortunately, you will probably have to draw 100 bad pages before you draw a good one; there are no shortcuts. Admittedly, art is somewhat like spit. It does not repulse or even worry us while it is still inside of us, but once it exits our body, it becomes disgusting. However, do not be discouraged. As you get more practice, you will have more control of your craft, and your ideas and ambitions will grow with your skill. Remember also that while there is an element of "play" in creativity, it is mostly work, and you have to enjoy the solitude of patient, hard work, because ultimately there is only the paper, the pencil, and you.

Do not obfuscate, or try to be clever; never disrespect your readers, belittle them, or assume you are smarter than they are. Write for yourself, and do not concern yourself with pleasing your audience (it is impossible, anyway). Always keep in mind that the emotional core of any story is its heart and soul. The outer shell of its form will necessarily follow from what you are trying to express. The trick is to get them all to work in tandem. It is all right not to know what it is you are trying to communicate, exactly, ahead of time. Part of the creative process is exploring our thoughts, letting our guard down, and laying ourselves on the line, as we try to work through these things. Chris Ware once said in an interview that art is not

merely a set of skills but a form of thinking; it has taken me years to fully grasp the implications of this statement.

The best comics are multi-layered and can be enjoyed many times over. The best cartoonists can be revisited often, and you can find something new in their work every time. If the quality is there in the initial creation, the rewards will never dwindle. No doubt there are bad epochs when tastes degenerate, but everything of quality eventually finds its audience. Sure, the artist may die and be forgotten, but the critic will live and be forgotten. The vast majority of critics are mere barnacles, cannibals who fancy themselves gourmands. Anyhow, time is the only critic with which you should concern yourself.

Although you have no control over the future, you have control over what you are creating right now, and if what you create is honest, it will be compelling. Whether or not it is truly good will be decided long after you are dead. But if you hedge your bets, compromise, prevaricate... you are lost. Something has to be at stake, a part of you has to die and be reborn into your work, if it is to "live" on that sheet of paper, cave wall, or assemblage of pixels. In the end, all we can do is try our best. We are none of us perfect.

APPENDIX

FURTHER READING

When I started teaching, I relied mostly on reams of photocopied handouts, which expanded with every class I taught. Fortunately, with the publication in 2004 of *McSweeney's Quarterly Concern* #13 (a special comics issue, edited by Chris Ware), I finally had an ideal textbook.

Besides *McSweeney's* #13 and my own assemblages of favorite essays and comics, I also gradually amassed an ever-shifting set of Powerpoint "slideshows." Eventually, the photocopies and slideshows morphed into my own textbook, *An Anthology of Graphic Fiction, Cartoons, and True Stories* (Yale University Press, 2006). A second volume of the *Anthology* was published in 2008, and together they formed a complete set. I briefly considered, before sanity intervened, editing a third volume, to include the many favorite comics I regrettably could not collect into the first two volumes, but I will leave that endeavor to the ages, or at least to a much younger, less broken human being.

Houghton-Mifflin has been publishing an annual volume, the *Best American Comics*, since 2006, and this series is a great way to stay current on the outstanding, noteworthy, and interesting work being done in the field. A rotating roster of guest editors helps keep the contents lively and varied.

Two books that are long out of print but well worth seeking out by the serious student are *The Smithsonian Collection of Newspaper Comics* and *A Smithsonian Book of Comic-Book Comics*, both edited by Bill Blackbeard. It should not be too difficult to obtain them in this instant-gratification age of eBay and online booksellers.

There exist today quite a few well-researched and lavishly produced reprint series of classic comics, as well as cutting-edge anthologies of current work. The meaty tome *Art Out of Time* (Abrams, 2006) and its sequel *Art in Time* (Abrams, 2010), both edited by Dan Nadel, provide an interesting overview of long-neglected and unfairly marginalized work.

The original version of the very book you hold in your hands first appeared as a supplement to issue 9 of Todd Hignite's lush and informative *Comic Art* magazine,

which appears to be on hiatus, although one hopes not permanently. In the meantime, I would highly recommend tracking down any and all of the nine back issues (searching online is a good starting point). The magazines are well worth your investment. Another option is to purchase Mr. Hignite's book *In the Studio* (Yale, 2006), which reprints some material from the magazine (and has much new material besides). *In the Studio* contains interviews with eight of the best contemporary American cartoonists, plus one with me.

The aptly named Web provides a platform for all kinds of discussions about comics, with no shortage of mean-spirited "experts" purporting to offer informed criticism; occasionally, and with a little help from the "search" function, one finds more high-minded fora. The Internet also serves as a great resource for the archiving of old comics as well as the continual upload of brand-new work. I imagine all of this will continue indefinitely, or at least until civilization irrevocably collapses.

Art Spiegelman's *Maus* (Pantheon, 1986, 1991) is not only a groundbreaking masterpiece but also a comics course unto itself, its every page a lesson in thought and construction. Even after re-reading it at least 50 times, I still discover new subtleties and complexities within it, and the story has lost none of its emotional power. A flashback: I shake my head in disbelief when I overhear one student earnestly describe *Maus* to someone as a book about "a bunch of mice in a concentration camp." Oy gevalt! I can think of no better argument for the absolute necessity and value of humanities education.

Lynda Barry's *What It Is* (Drawn and Quarterly, 2008) remains the best, most inspiring, mindblowingest book on tapping into one's own innate creativity. The book is a beautiful, lovingly crafted art object in and of itself, and that alone is worth the price of admission. But Lynda also expands our idea of what an image is and can be, teaches us how to remember, asks us to ponder philosophical questions, and encourages us while gently guiding us through an accessible (and potent) creative process. Best of all, she does this without even a smidge of pretension. If you ever get the chance, attend her creative workshop "Writing the Unthinkable," which, as this author can testify, will profoundly change your life.

The list continues, but this should be plenty to get you started on a basic "core" comics education. Needless to add, you should also take care to educate yourself fully in many other areas besides comics. Most great cartoonists, both by nature and necessity, tend toward the autodidactic, and thus are unsurprisingly well read and intellectually engaged, with a wide variety of interests.

And, oh, read *Drawing on the Right Side of the Brain* by Betty Edwards. It will help you immeasurably.

SELECTED BIBLIOGRAPHY

This is by no means a complete documentation of every source used in the book and is meant simply as an extension of the list of further readings.

Clowes, D. *Modern Cartoonist*. Seattle: Fantagraphics Books, 1997.

Frost, R. *The Complete Poems*. New York: Henry Holt and Company, 1930, 1949.

Gleick, J. *Chaos: Making a New Science*. New York: Penguin, 1987.

Hazan, M. *Marcella's Italian Kitchen*. New York: Knopf, 1986.

Klee, P. *The Diaries of Paul Klee, 1898–1918*. Ed. F. Klee. Berkeley: University of California Press, 1964.

Kochalka, J. *The Sketchbook Diaries*, Vol. 1. Marietta, GA: Top Shelf, 2001.

Mamet, D. *On Directing Film*. New York: Penguin, 1991.

Mendelson, L., and C.M. Schulz. *Charlie Brown and Charlie Schulz*. New York: Signet, 1970.

Murch, W. *In the Blink of An Eye*, 2d ed. Los Angeles: Silman-James Press, 1995, 2001.

Prose, F. *Reading Like a Writer*. New York: HarperCollins, 2006.

Salinger, J.D. *The Catcher in the Rye*. New York: Little, Brown,1951.

Steinberg, S., with A. Buzzi. *Reflections and Shadows*. Trans. J. Shepley. New York: Random House, 2002.

Thomas, L. *The Lives of a Cell: Notes of a Biology Watcher*. New York: Penguin, 1974.

Ware, F.C. *Jimmy Corrigan: The Smartest Kid on Earth*. New York: Pantheon Books, 2000.

Woodring, J. *The Comics Journal*, no. 192 (Dec. 1996): 2.

"I am still searching for that wonderful pen line that
comes down when you are drawing Linus standing
there, and you start with the pen up near the back of
his neck, and you bring it down and bring it out, and
the pen point fans out a little bit, and you come down
here and draw the lines this way for the marks on his
sweater. This is what it's all about —to get feelings of
depth and roundness, and the pen line is the best
pen line you can make. That's what it's all about. "